The Lonely Octopus:
A Wordless Book

The Lonely Octopus: A Wordless Book

Annabelle Markwick

Star Books
2015

Copyright © 2015 by Annabelle Markwick
All rights reserved. This book or any portion thereof may not be reproduced or used in any manner whatsoever without the express written permission of the publisher except for the use of brief quotations in a book review or scholarly journal.
First Printing: 2015
ISBN 978-1-326-15214-7
Star Books Glastonbury, Somerset, UK

Dedication

To my parents. Thank you for supporting my dreams.

Introduction

A wordless book uses only pictures to tell a story, and get across a message to the audience. I like wordless books because to some extent the story is open to interpretation, as different people will look at a picture and see a slightly different story behind it. Everyone will have a different experience of the same images. Also, pictures describe things that words can't. Here is the story of a lonely octopus, and his search for love. I hope that you enjoy 'reading' it in your own unique way.

Thank you for buying my book!

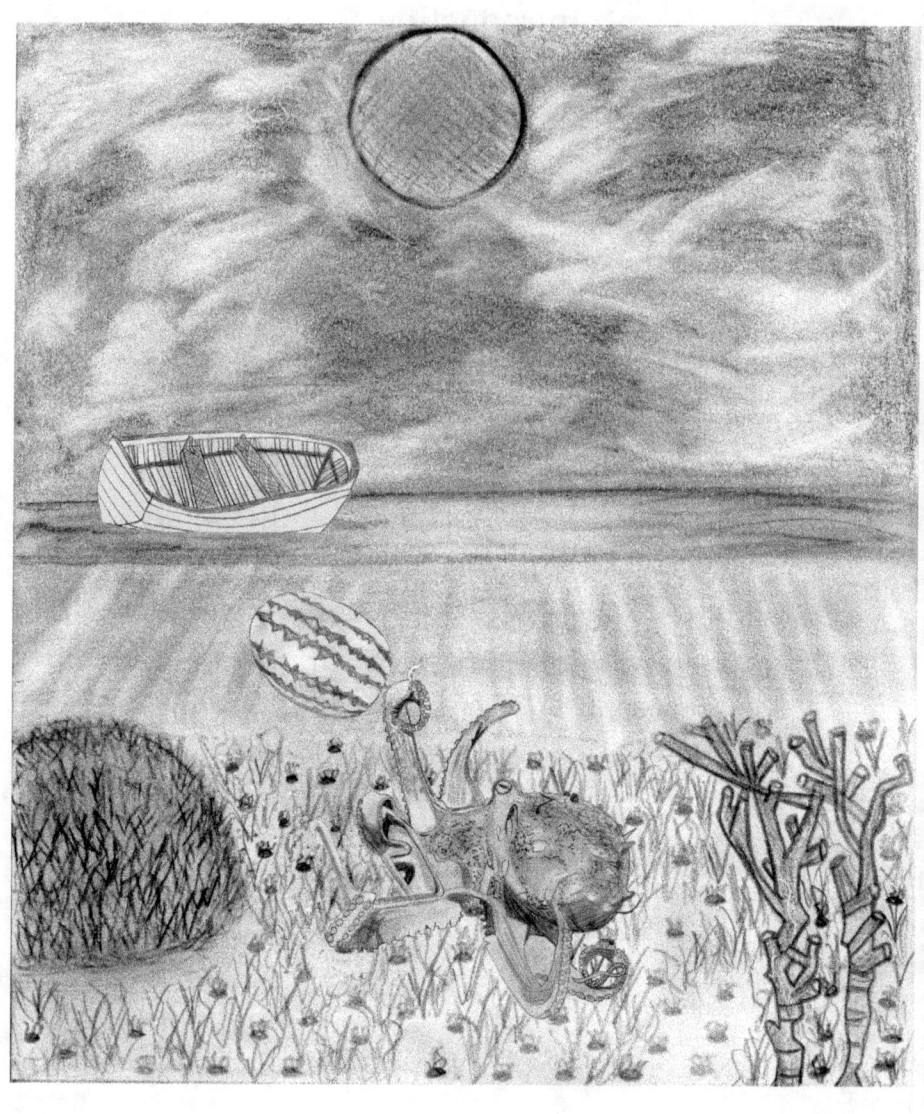

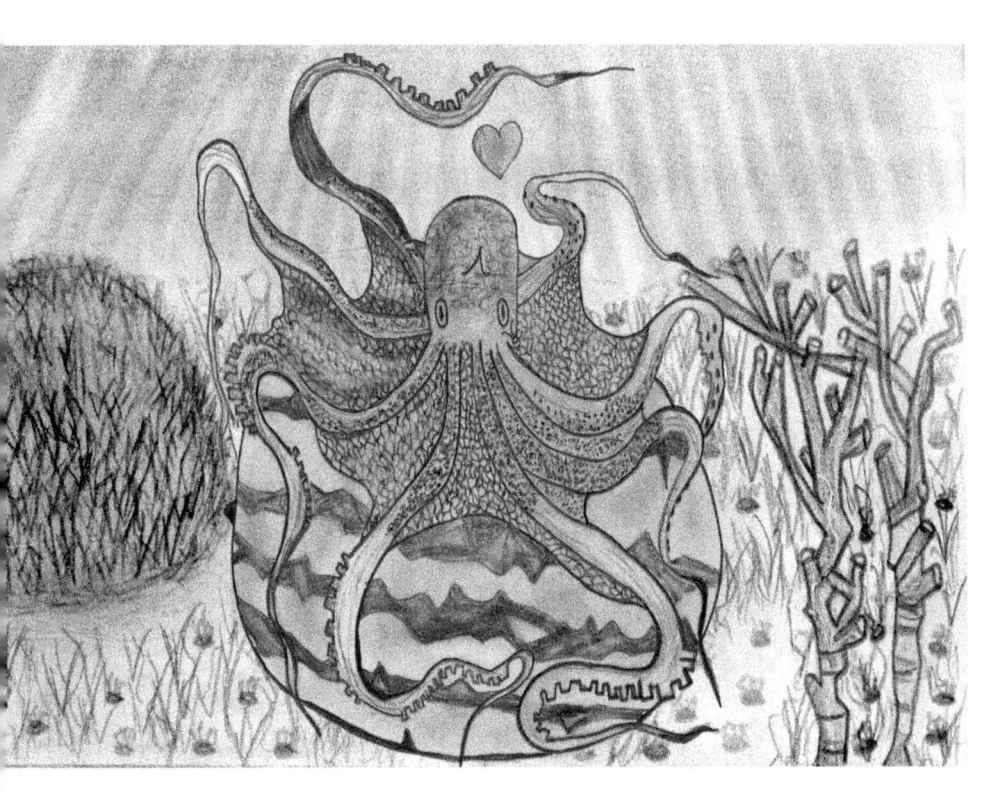

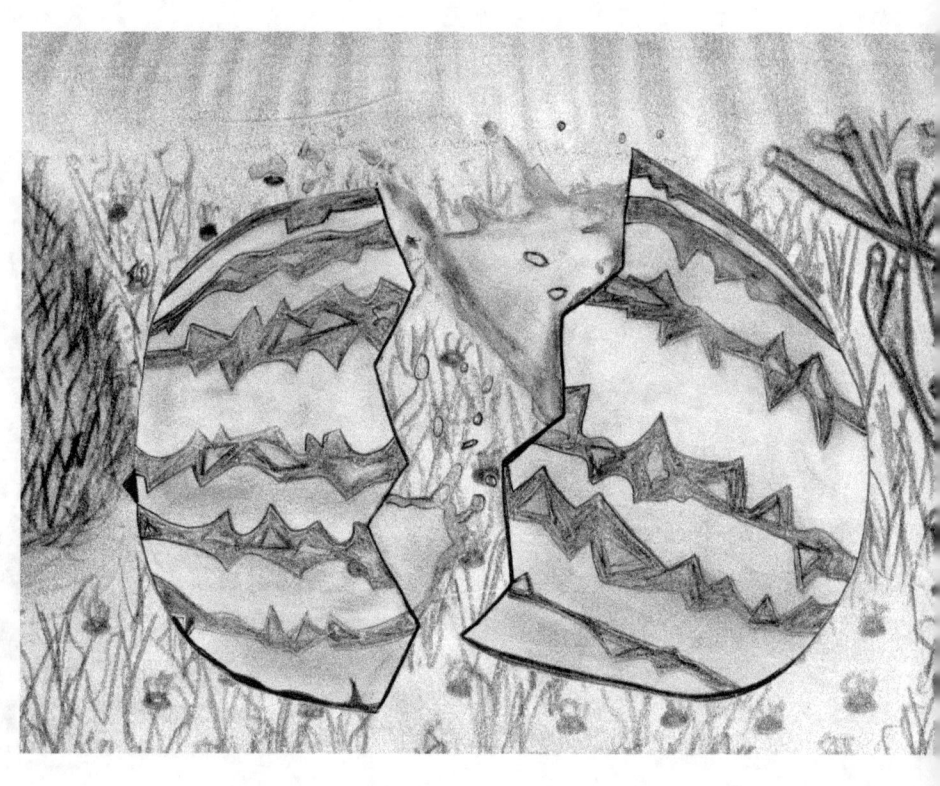

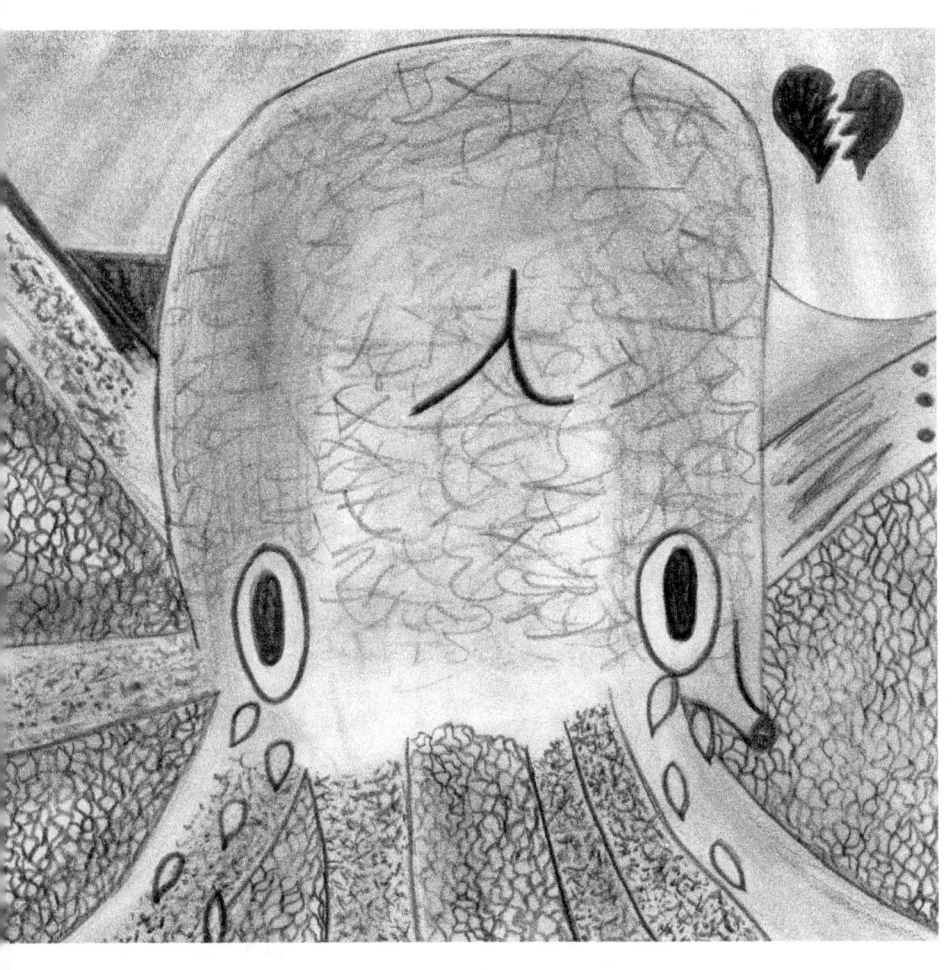

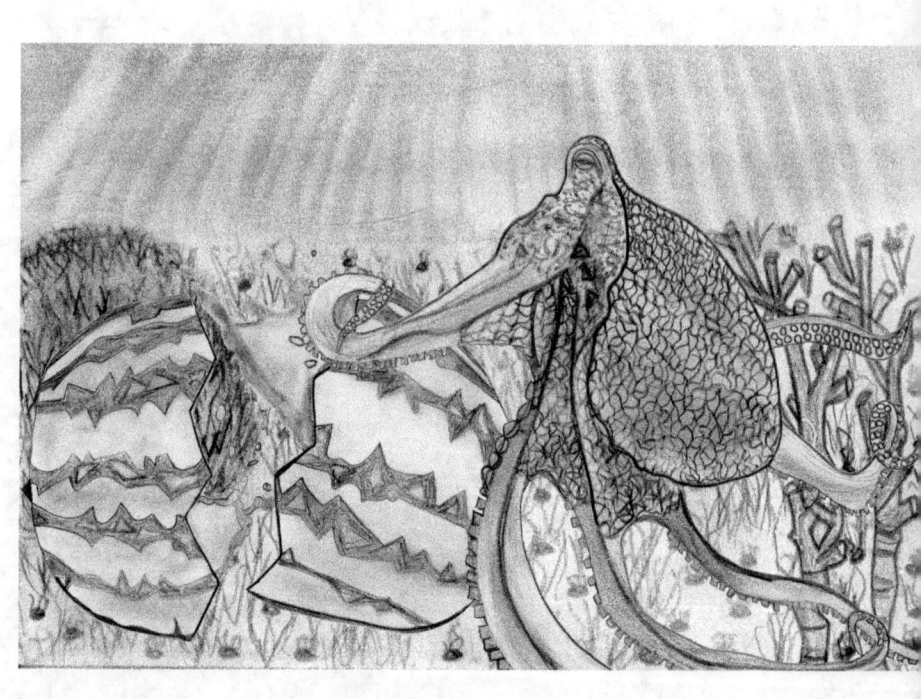

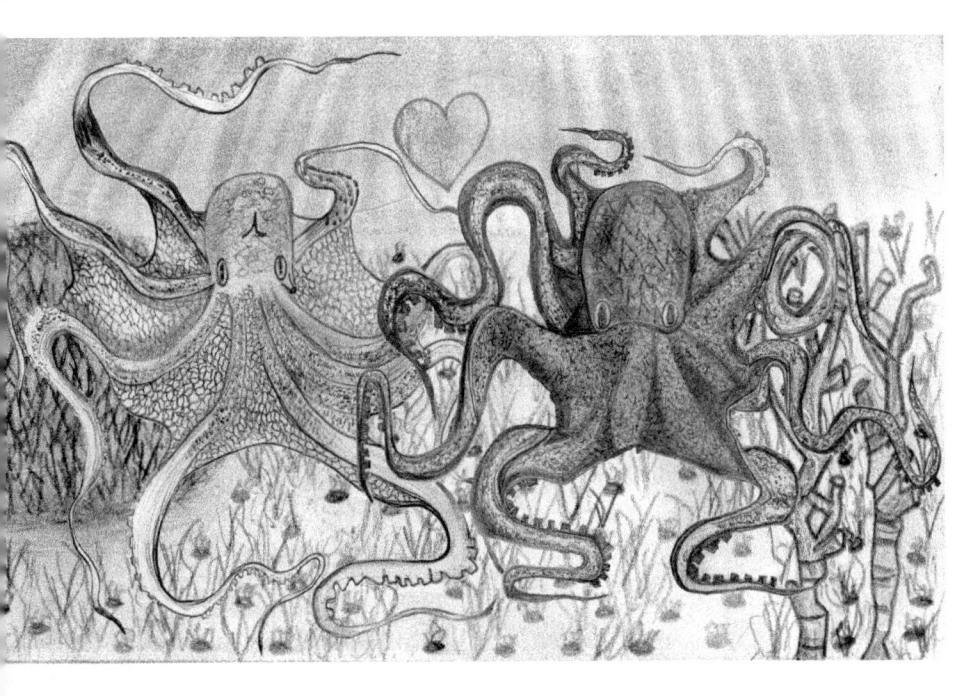

www.ingramcontent.com/pod-product-compliance
Lightning Source LLC
Chambersburg PA
CBHW070434180526
45158CB00017B/1270